Landscapes in Pastels

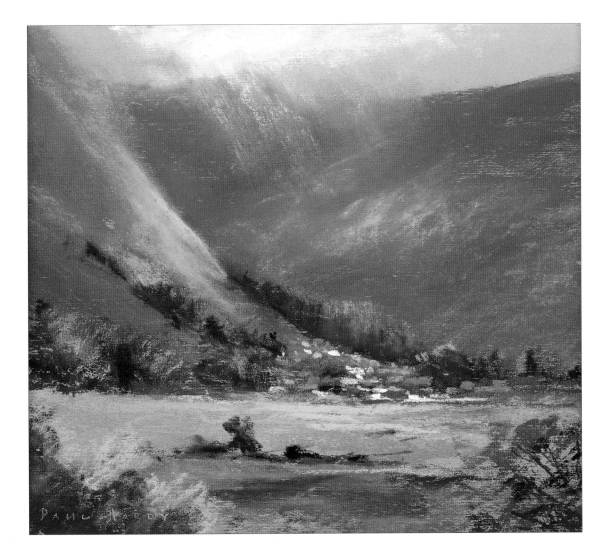

This book is dedicated to
Aubrey Phillips,
who introduced and inspired
me in the use of pastels.

Landscapes
in Pastels

PAUL HARDY

SEARCH PRESS

First published in Great Britain 2001

Search Press Limited
Wellwood, North Farm Road,
Tunbridge Wells, Kent TN2 3DR

Reprinted 2002, 2003, 2004, 2005, 2007, 2008

Text copyright © Paul Hardy 2001

Photographs copyright © Search Press Studios 2001, except those on pages
1, 5, 7, 26, 27, 28, 35, 36, 44, 45 and 46, which are © Nigel Cheffers-Heard

Design copyright © Search Press Ltd. 2001

ISBN: 978 0 85532 918 1

The Publishers and author can accept no responsibility for any consequences
arising from the information, advice or instructions given in this publication.

Suppliers
If you have difficulty in obtaining any of the materials and equipment
mentioned in this book, then please visit the Search Press website for details
of suppliers: www.searchpress.com

Alternatively, you can write to the Publishers at the address above, for a
current list of stockists, including firms who operate a mail-order service, or
you can write to Winsor & Newton requesting a list of distributers.

Winsor & Newton, UK Marketing
Whitefriars Avenue, Harrow,
Middlesex, HA3 5RH

Publishers' note

All the step-by-step photographs in this book feature the author,
Paul Hardy, demonstrating how to paint landscapes with pastels.
No models have been used.

Page 1

Hills and Valley
Size: 230 x 205mm (9 x 8in)

*This type of painting, which is full of colour and shows everything
visible from the viewpoint, can be appealing and dynamic. There is
a power in this painting which makes an immediate impact on the
viewer; it is unhampered by detail – what you see is what you get.*

Pages 2/3

Springtime
Size: 395 x 280mm (15½ x 11in)

*The stillness in this picture does not change; it is constant in the
evocative sense. It only needs to be seen – it needs no translation
– to convey its meaning to the viewer.*

Printed in Malaysia by Times Offset Sdn Bhd

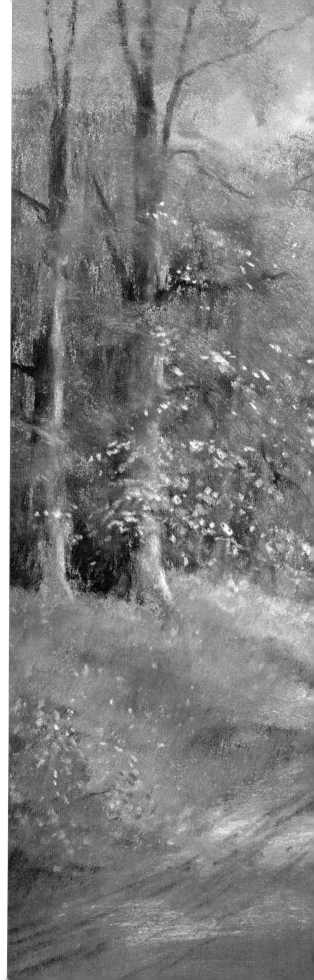

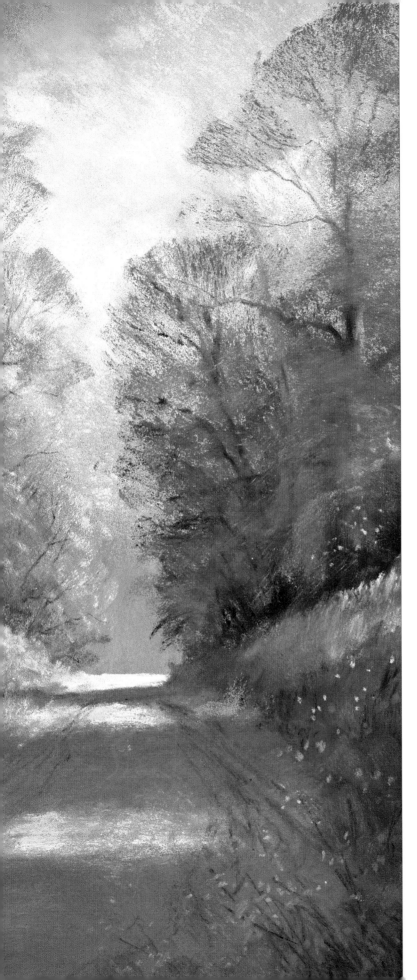

Contents

Sunny Day
Size: 255 x 380mm (10 x 15in)

Some subjects have a more universal appeal than others and this type of scene captures the eye at once. On a sunny day all the colours vibrate and blend into a total picture. This scene, painted early in the morning with no distractions, imparts a aura of tranquillity.

Introduction

Pastels are wonderful to work with and they give you a certain thrill right from the first time you use them. They are vibrant, easy to use and have unique qualities: speed and directness of application, and a permanence and vitality that other mediums lack.

The versatility of pastels is a constant delight – an exciting range of effects can be created, from the soft and subtle tones of an early morning, to the strong and dynamic impression of a stormy landscape. Pleasing results can even be achieved also using just one colour and tinted paper. You will soon discover a satisfaction that begs definition when you start using the enormous range of colours that are available, and experimenting with the different paper surfaces.

One of the best teachers for painting the landscape in this medium is the landscape itself. As an artist you should constantly observe your surroundings. If you do this you will soon become aware of the composition and colour of things around you, and the play of light and shade on what you see. Your interpretation of these elements will give you great satisfaction, as you apply the pastels and watch your fields, trees and flowers spring to life.

I travel around a lot giving demonstrations, taking workshops and meeting art groups and I frequently hear the comment 'pastels are so messy!' I always reply that such an attitude denies many artists the discovery of one of the greatest pleasures of their painting lives and that they should 'have a go'. I am greatly encouraged by the increasing number of people who are now using pastels, and especially happy about those who take my advice and are 'going to give them a try.'

I want to open up a whole new world and share the endless possibilities of pastels with you. As you read and practise the demonstrations in this book you will discover the delights and beauty of working with a medium that is both exciting and inspiring. Use your eyes and experiment with colours and techniques – and you will enjoy the challenge of the landscape and the amazing versatility of pastels.

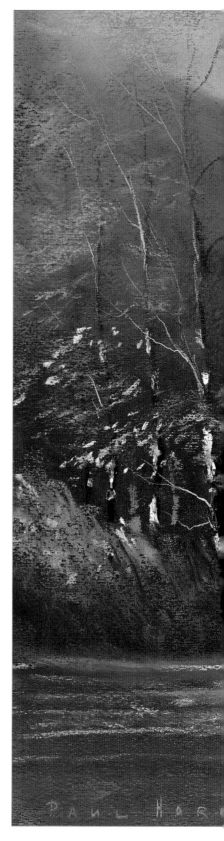

Light and Shade
Size: 255 x 205mm (10 x 8in)

Nature is there to inspire us and should mirror our thoughts. This is a scene that could be complicated, but I simplified it. It has contrast in tonal values and moves from light to dark and dark to light, keeping the eye active discovering different points of view. The buildings are incidental but they do give scale to the whole scene.

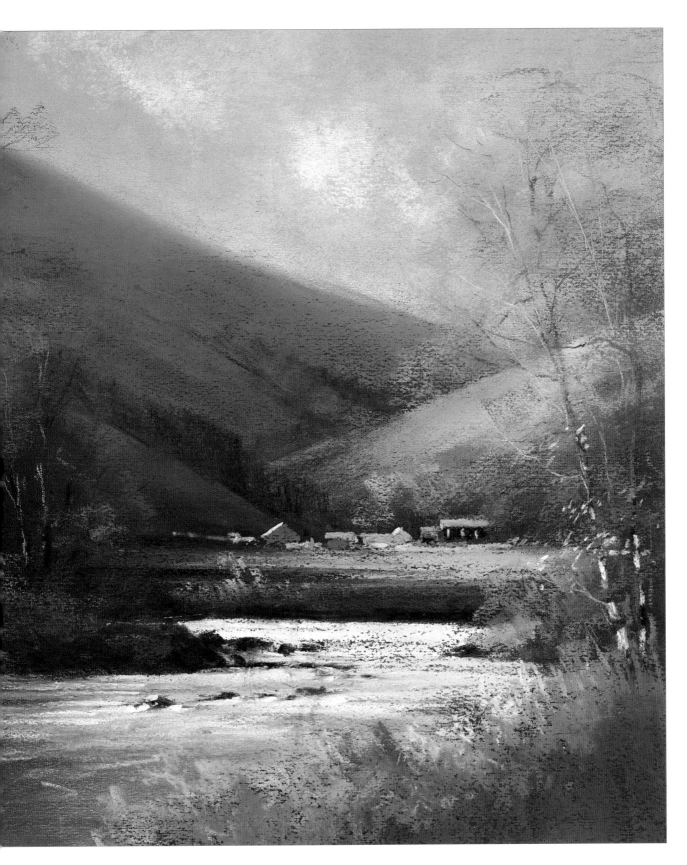

Materials

Pastel is the ideal medium for the beginner, especially when rendering landscapes, as it requires the minimum of equipment and is easy to use. A few colours and some paper are all you need to get started.

Pastels

Pigment is the common ingredient of all painting mediums; it is the binder that makes the pigment into watercolours, oils, pastels, etc. Buy the best pastels that you can afford. Good-quality soft pastels are almost pure pigment – only a small quantity of gum is used to hold it together– and they have a depth of colour far greater than any other medium.

The availability of pastels has changed dramatically over the last few decades. Once it was difficult to find what you needed, but now there is a far greater choice, and new brands appear all the time. Most pastels are available in a range of tints/shades of individual hues; the pale tints have white added to the pigment, the dark ones black.

What brand of pastels and, more specifically, what colours to use for a painting is a personal choice. My current palette of colours has evolved over the years to suit my specific needs, but this does not exclude me from using others in my work. There are several sets of colours available, some with colours more suited for landscapes; such sets are a good starting point for beginners.

Charcoal sticks and pencils are also essential to my palette.

Papers

The painting surface is extremely important and the 'tooth' (the roughness/smoothness) of the surface plays a vital part in the finished work.

There are lots of papers that are made specifically for pastel work, some have a smooth surface on one side and a textured surface on the other.

You can also paint on abrasive papers (fine grade sandpapers). These have a pronounced tooth that takes up lots of pigment allowing you to create really vibrant colours.

The choice of what colour paper you use is also important, since areas of the paper may be left uncovered – a tinted paper can provide harmony or contrast to your painting. Black paper can create a really dramatic result.

Other equipment

I prefer to stand and paint at an easel with my painting board and paper vertical. Pastels create a lot of dust, so working this way allows the dust to fall from the surface of the paper.

My painting boards are simply sheets of plywood. I use a few spring clips or masking tape to mount the paper on the board.

I usually use my finger or the heal of my hand to blend pastels on the paper but, occasionally, I use a paper stump (it looks like a pencil with points at both ends) to blend small areas of colour.

Spray fixative can be used during the initial stages of a painting to fix the base colours prior to overlaying others. Some pastel artists spray finished paintings with a light layer of fixative when mounting them under glass.

Exploring pastels

The best way to get to know the endless possibilities of pastels is to experiment with these simple exercises. Try making different marks by using the tip and the side of the pastel stick. Lay one colour over another and discover the opacity of pastels. Use your finger to blend the colours together; unlike wet mediums which are blended on a palette, pastels are blended on the paper.

Making marks

The most common way to use pastels is to the block in areas of colour using the side of the pastel stick. The amount of pigment released on to the surface will depend on the applied pressure and the surface texture of the paper. These initial marks will invariably leave lots of the underlying colour of the paper visible. You may want to use this effect to advantage, but you can also smooth out the pigments, pushing them down into the surface texture, by rubbing the area with your finger.

Linear strokes, in the form of cross hatching, straight and curved lines and small dots of colour are best worked with the tip of the pastel stick.

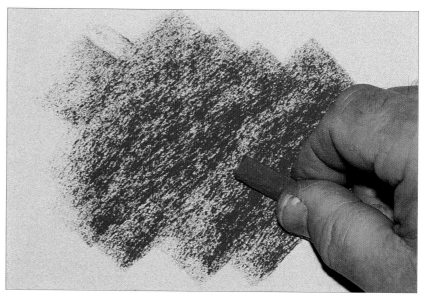

Use the side of the pastel to create broad strokes to cover large areas of paper.

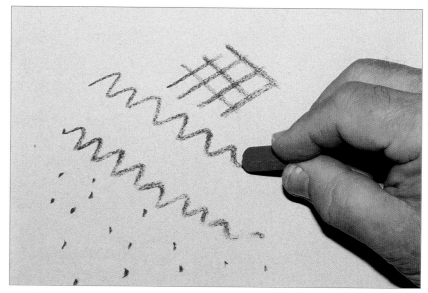

Use the tip of the pastel to create fine detail.

Blending

Your paper is your palette; all colour mixing (blending) is performed on the paper. Pastels are quite opaque, so, when you lay one colour over another the bottom colour becomes hidden. However, when you rub the surface with your finger the pigments of underlying colour merge with those of the top layer to create a blend.

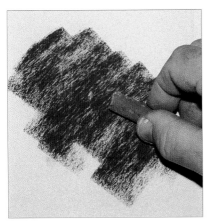

Use the side of, say, a red pastel to cover an area of paper.

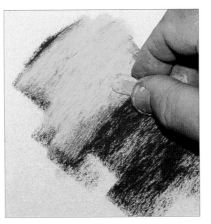

Overlay the red with a yellow pastel and note how opaque the colour is.

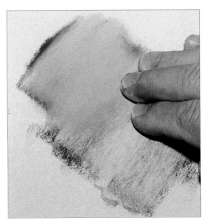

Use your finger to blend the colours together and create orange tones.

Effects of surface texture

The type of paper you choose to paint on has a great effect on the results of the finished work. The surface texture of the paper can range from quite smooth to very rough and the 'tooth' of the paper affects the way it holds the pastel pigment. The three examples below, of different types of paper, show marks made with the same degree of applied pressure. The right-hand side of each picture shows the initial marks, the left-hand side shows the effect after being blended.

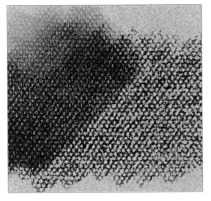

Textured side of pastel paper.

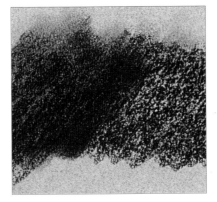

Smooth side of pastel paper.

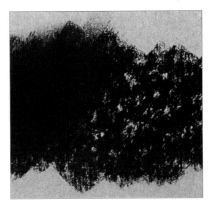

Abrasive paper.

Composing a painting

Most landscape painters develop their own ideas on how to paint landscapes. Remember that nature does not provide ready-made subjects, our responsibility is not to copy what we see but to create an image that contains nature's component parts. You are interpreting a three-dimensional scene on to a flat, two-dimensional surface. Explore the different elements of a scene and form a personal relationship with them. Adjustments will be made during the process of painting as the eye moves around. On these and the next few pages I discuss the basic elements of composition; there are no hard and fast rules and you will, no doubt, develop your own ideas about what makes a good painting.

Focal point

Landscape compositions should appear to be balanced but not symmetrical. A focal point (centre of interest) should be established before you start painting. This could be an object, such as a building, or an indefinable area to which the eye is drawn. The focal point can be anywhere on the paper but, usually, it is placed slightly off-centre. Compare the two simple sketches opposite.

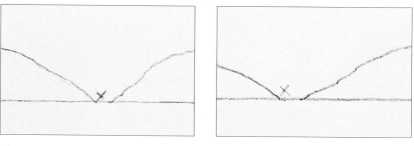

These two sketches show the importance of the focal point. The left-hand sketch, with a centred focal point, is too balanced. Placing the focal point slightly off centre still creates a balanced composition but, although the eye is drawn to that point, it is invited to move around the picture.

Horizon line

The horizon line is always at eye level. However, you can draw the horizon line anywhere on the paper. When I want to paint a dramatic sky against a tranquil landscape I place the horizon quite low down on the paper. Conversely, where the landscape is more interesting than the sky, I place my horizon line in the top half of the painting. Again, never cut the composition into two equal parts by placing the horizon in the middle of the paper.

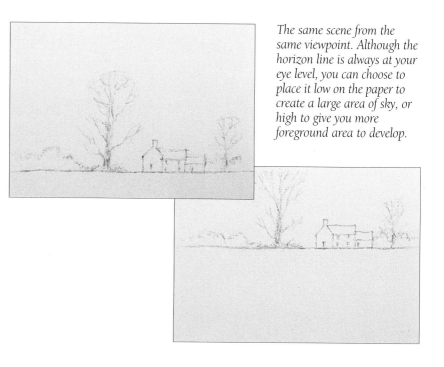

The same scene from the same viewpoint. Although the horizon line is always at your eye level, you can choose to place it low on the paper to create a large area of sky, or high to give you more foreground area to develop.

Skies

Skies are a challenging subject to paint as they never remain still; even the blue of a cloudless sky changes colour every minute.

Use the sky to set the mood of an entire scene, regardless of the other elements of the composition. The sky must always be in harmony with the landscape, be it just a simple background or the principle feature of the painting.

The sky is the main source of light, so be prepared to use a wide range of colours. However, it is not always the palest part of a painting; sometimes it can be the darkest, with threatening clouds covering most of it.

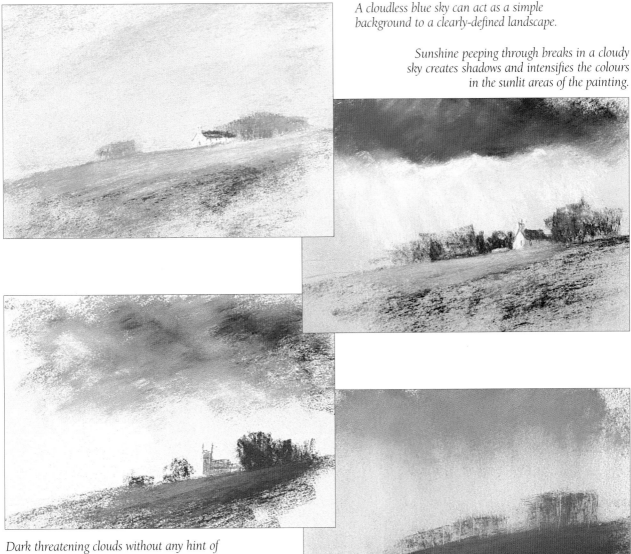

A cloudless blue sky can act as a simple background to a clearly-defined landscape.

Sunshine peeping through breaks in a cloudy sky creates shadows and intensifies the colours in the sunlit areas of the painting.

Dark threatening clouds without any hint of sunlight create contrasts in tonal values.

Rain changes the whole atmosphere of a scene and gives us the challenge of painting with muted colours.

Trees

Trees have form and mass, as well as colour, height and width. Before starting to painting deciduous trees it is a good idea to study them in winter when they are bare of leaves and you can see the skeletal form of the branches and twigs. Make lots of sketches, noting the difference between the shapes of individual trees and those growing close together in woods. When clothed in leaves trees become a greater challenge. Do not try to recreate each leaf – the patterns of light reflecting off the leaves are more important than leaf texture. Block in the rough shape of the tree, then redefine its outline by painting the 'negative' edge of the sky into the tree. This method gives shapes an accidental quality which is more natural than contrived.

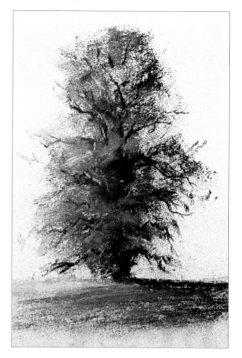

Specimen trees such as this oak and the elm (below) can be the main subject of a landscape painting. Studying their skeletal shapes in winter, when they are bare of leaves, will help you paint them in full leaf.

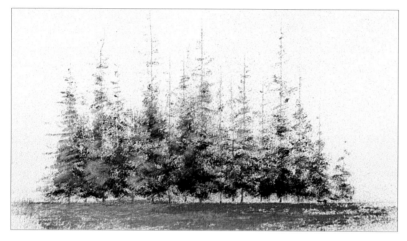

Groups of trees, such as this stand of pines and the avenue of poplars (below) are often found in the landscape. They may appear regimental in shape, but they are quite irregular and definitely not static.

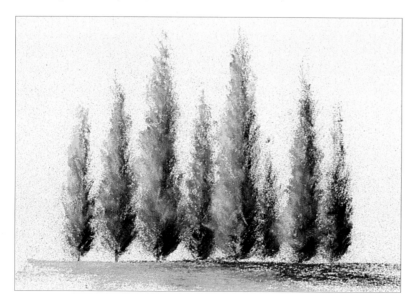

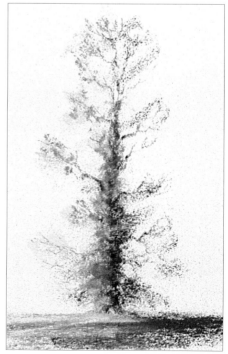

Water

Water has a place in landscapes and it can be used to create a variety of moods. It can be used as the main element in the foreground or as a distant detail. Water has many forms – shallow puddles, fast-running streams, slow-moving deep rivers, waterfalls, snow and ice – so, again, take time to study the different types. Note how water reflects the colours of the sky and the landscape around it. Compare the shapes of reflections in still water with those in moving water. Here, I have included three sketches of very similar scenes but at different times of the year to illustrate some of the many types of water you can come across. I have also included a sketch of a waterfall which has both fast-moving and still areas of water.

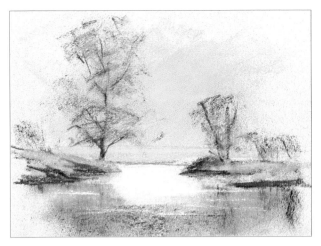

In this scene the river is quite deep, with a flat, mirror-like surface that reflects the images around the water.

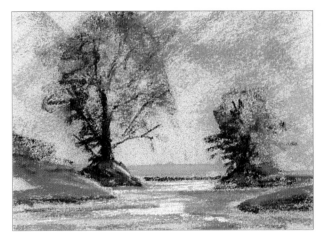

When the water level drops, the surface becomes ruffled by the pebbles on the river bed, causing the reflections to break up.

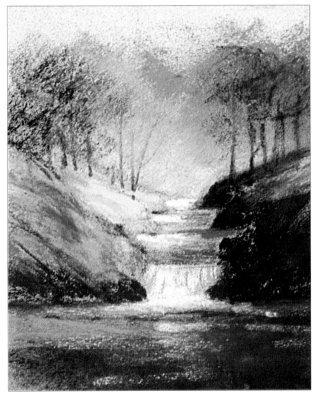

Waterfalls give you the opportunity of combining still and moving water in one painting.

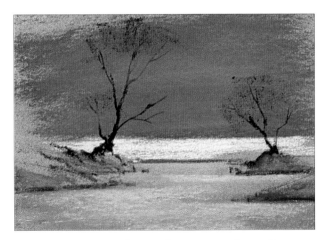

Sometimes, in winter, the river freezes over to form a flat opaque surface that hardly reflects anything at all.

Field sketches

Field sketches are the starting point for painting landscapes and you should endeavour to practise sketching at all times. A sketch book is a means of recording scenes – whole vistas and detailed parts of the landscape – which will prove a useful reference source for many years. Always make notes about the atmospheric conditions prevailing at the time, and mark the direction of the source of light. Never discard such sketches. I usually sketch using soft pencils, charcoal and, of course, pastel but, sometimes, I use watercolours.

When sketching, I view my subject from different places. I look at it from a distance, then move in closer. This observation helps me decide on the composition and design of the final painting. If you have problems with a particular scene start by sketching in everything you can see. Then turn away and, looking just at your sketch, start to erase things that do not add anything to the composition. Remember that your paintings are not photographs, so you can use artistic licence to add or delete at will.

I always place the horizon line above or below the centre of the paper, as a centred horizon will always split the painting into two. The horizon line is always horizontal to your eye level, so your viewpoint will affect its position relative to the subject. However, you can be selective about what parts of a scene you paint, and this allows you to position the horizon line at any point on the paper. I like to have a low horizon when the sky is the most dominant part of the painting, and a high horizon where there is more interest in the foreground.

You should also consider where to place the focal point or centre of interest. Use the lines of nature to help bring the composition together. Again, never place the focal point in the middle of the paper.

On these pages I show you a few sketches of the same scene made from different viewpoints. Each sketch would make a good painting

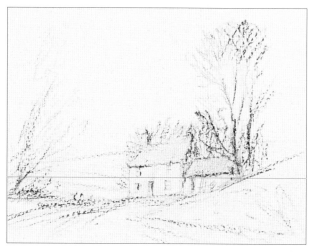

This sketch was made quite close to the buildings. At this point the road is quite flat and the horizon line, shown in red, is in the lower half of the composition, roughly level with the top of the door. The curve in the road leads the eye to the focal point, the buildings, which are placed slightly to the right of centre. The trees on either side provide a frame for the composition and also link the foreground land to the sky.

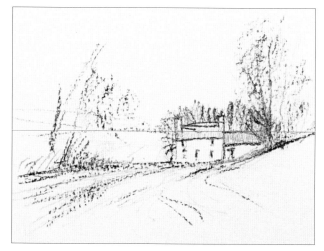

Going back up the road, which is now on a downward gradient, raises the eye level to the roof line of the right-hand building. New hills appear in the distance, and there is more foreground. The basic composition is still quite pleasing, but, as the horizon line virtually cuts the composition in half, I would overcome this by reducing the area of foreground and adding more sky.

I went to the top of the hill to make this sketch. The horizon line, now in the top half of the paper, is virtually level with the distance hills. From this vantage point, I can see down into the valley below the buildings giving added interest in the middle distance. I chose this sketch as the basis for the pastel painting below.

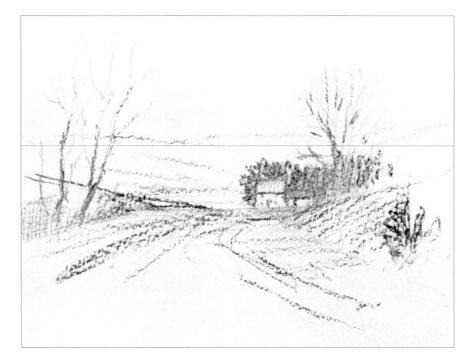

Through the Valley
Size: 220 x 150mm (8½ x 6in)

This painting is based on the field sketch above.

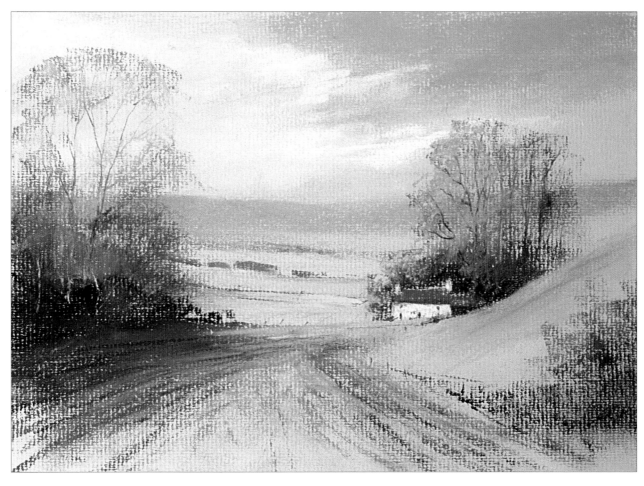

Hills and Vale

For my first demonstration I have chosen a very simple landscape that requires the minimum of drawing. A few guide lines are all that is needed to set the scene. Although this is a landscape, the sky dominates the composition and sets the mood of the painting. The idea is to depict space on a large scale, so there is hardly any detail. There is no definite focal point, just a space below the distant horizon on which the eye settles before exploring the rest of the painting. In the finished painting, I added the indication of a few sheep to help set this point.

I painted this demonstration on a 560 x 380mm (22 x 15in) sheet of 400 grade sandpaper, but I worked within a 420 x 350mm (16½ x 13¾in) aperture.

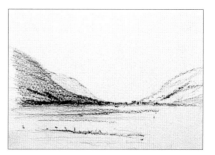

I based the demonstration painting on this initial tonal sketch which was drawn in charcoal.

Colours

Blue/green	Crimson lake	Purple
Burnt umber	Earth green	Sap green
Cadmium yellow	Grey	Sepia (pastel pencil)
Cerulean blue	Hooker's green	Violet
Cobalt blue	Olive green	White
Chrome yellow	Prussian blue	Yellow ochre

1. Use a sepia pastel pencil to draw a border and the horizon.

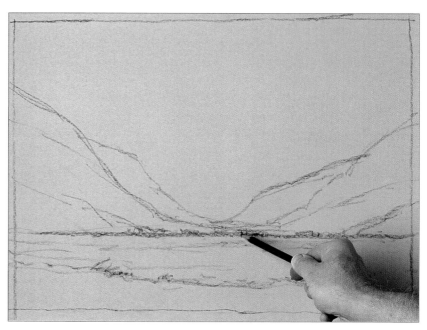

2. Sketch in the outlines of the composition, then mark the focal point (centre of interest).

3. Use a mid tone cerulean blue to block in the upper centre area of the sky.

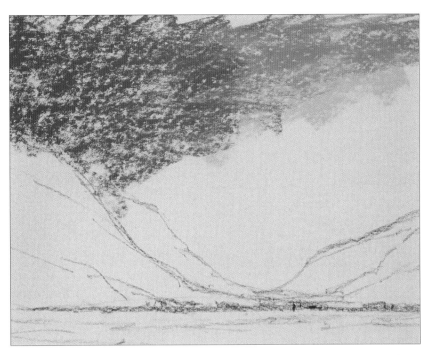

4. Add some cobalt blue over the top part of the sky.

5. Complete the blue part of the sky by blocking in the left-hand side with dark Prussian blue.

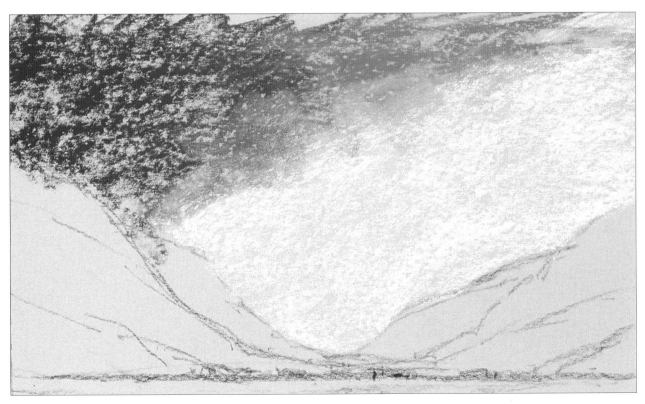

6. Block in the rest of the sky areas with a pale yellow ochre, varying the pressure as you work.

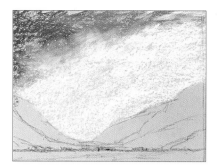

7. Apply a mid tone yellow ochre over the pale yellow area, taking it up into the pale blue sky.

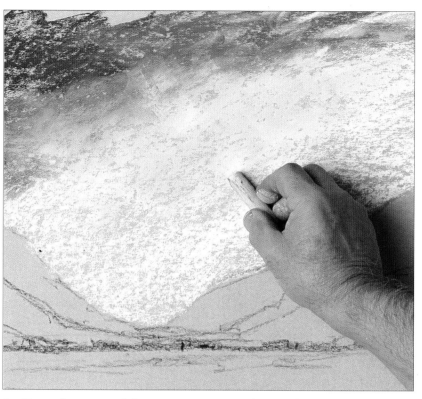

8. Use pale crimson lake to create a warm glow to the centre of the sky.

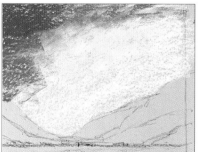

9. Finally, use a mid tone violet to darken the left-hand corner of the sky.

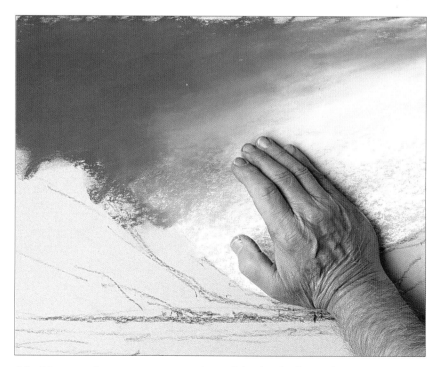

10. Now use long sweeping strokes of the heel of your hand to blend the colours together.

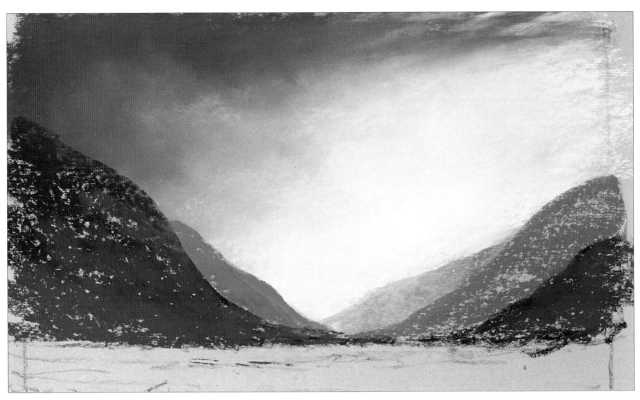

11. Block in the left-hand hills. Use mid violet for the distant hill, mid blue/green for the next nearest, then dark blue/green and Prussian blue for the nearest hill and the marks along the horizon. Working from the most distant, block in the hills at the right-hand side. Use pale violet, mid blue/green, then dark blue/green with touches of very dark blue/green. Soften the nearest hills with touches of mid grey.

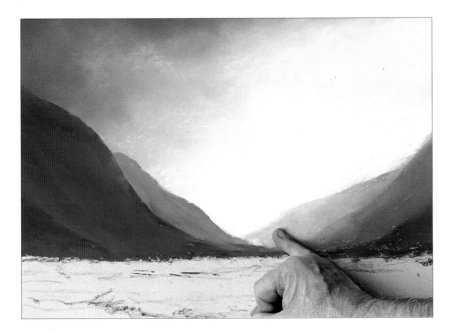

12. Use the heel of your hand and your finger to blend the colours and to develop the contours of each hill.

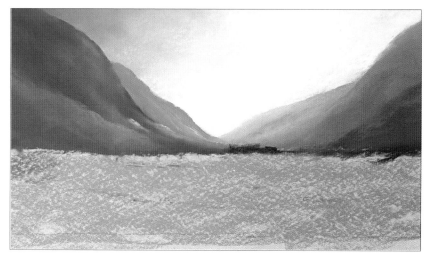

13. Use tones of burnt umber and olive green to continue developing the background. Apply touches of pale yellow ochre to suggest sunlight on the nearest hills.

14. Block in the whole of the foreground with sap green.

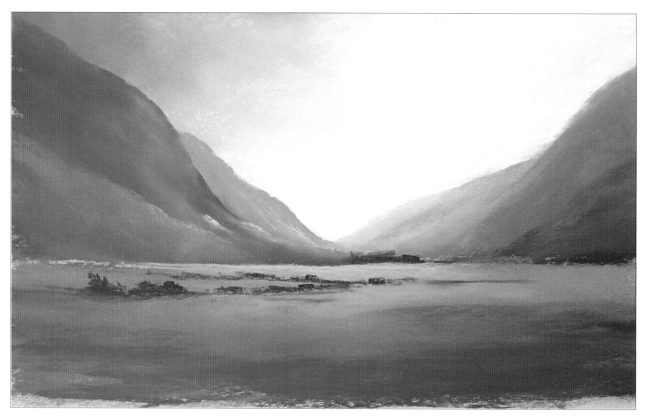

15. Working from the left-hand side, apply Hooker's green, then sap green across the paper. Blend the colours together. Work in dark Hooker's green at the left-hand side and across the bottom of the foreground. Apply chrome yellow against the horizon, adjacent to the focal point. Bring this colour forward, gradually reducing its intensity. Create some bushes in the middle distance with dark Hooker's green, then add a layer of Prussian blue over the grasses in the foreground.

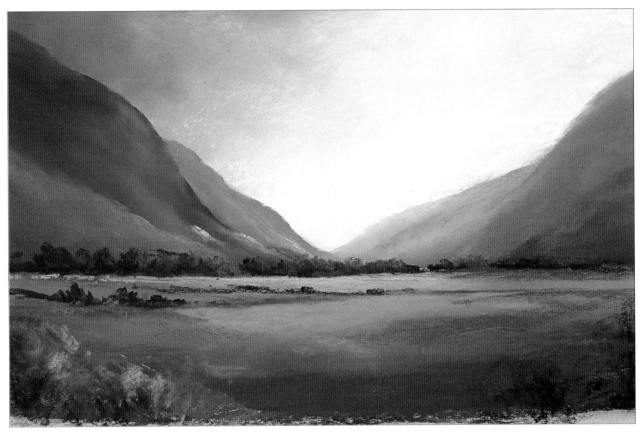

16 Use dark blue/green and very dark purple to work a tree line across the horizon and to add more shape to the middle distant foliage. Add an indication of foliage in the foreground to create a sense of depth. Create highlights with touches of sap green.

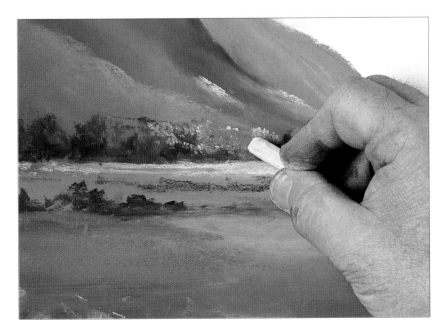

17. Use cadmium yellow to create highlights on the distant trees.

18. At this stage I decided that the bushes in the middle distance intruded too much, so I blocked over them with dark earth green.

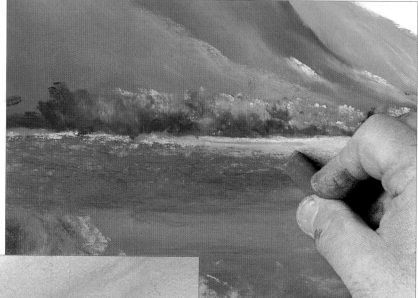

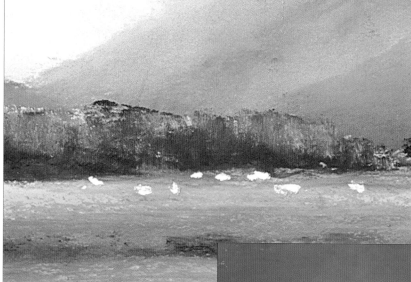

19. Develop the centre of interest by making a few small marks with a white pastel to indicate a few sheep. At this distance, there is no need to make these marks too detailed.

20. Use the white pastel to block in a few wispy clouds – soften the tops of them with your finger.

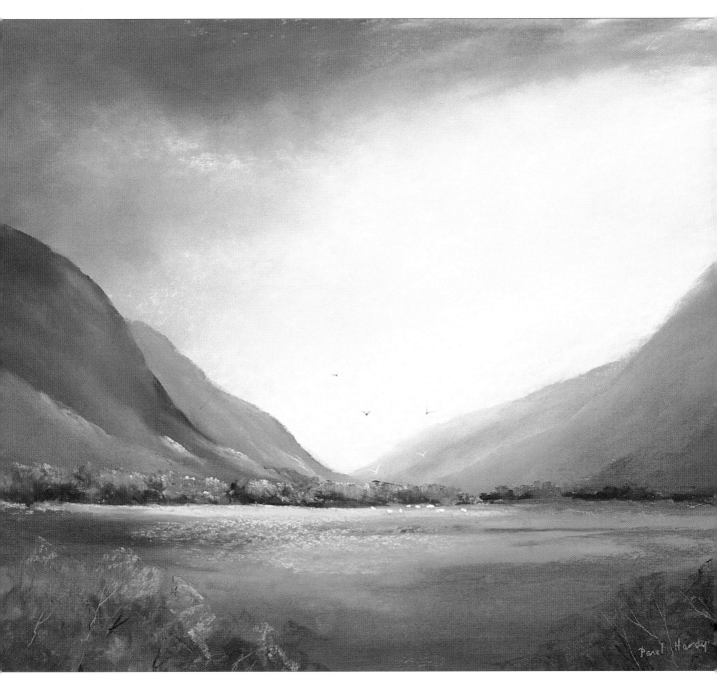

The finished painting
420 x 350mm (16½ x 13¾in)

*I added more detail in the foreground, then completed the painting
by drawing a few birds in the sky. At this stage, I also decided to
crop the painting at the sides to make a more pleasing shape.*

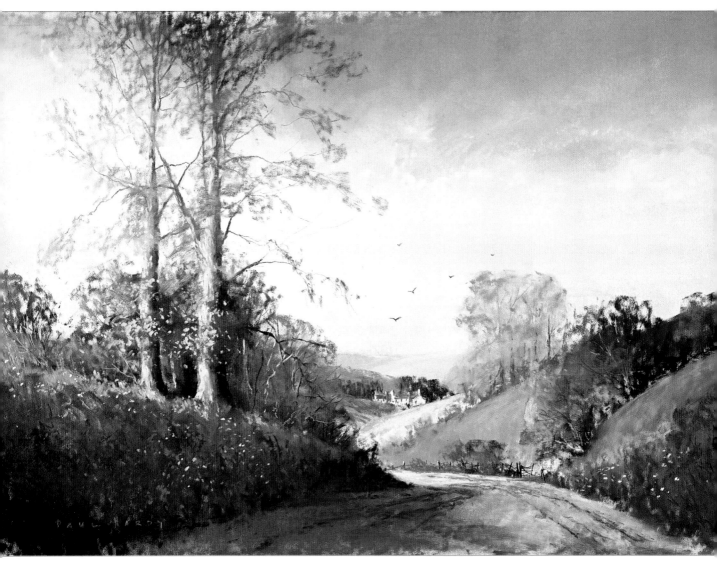

Morning is Broken

Size: 510 x 380mm (20 x 15in)

Much of the appeal of landscapes is in the strength of what is being expressed. Here it is the warmth of the sun, the rich colours of late autumn and the deep shadows. The road leads us into the picture; it makes us wonder what is round the corner before taking the eye through to the cottages on the distant hillside.

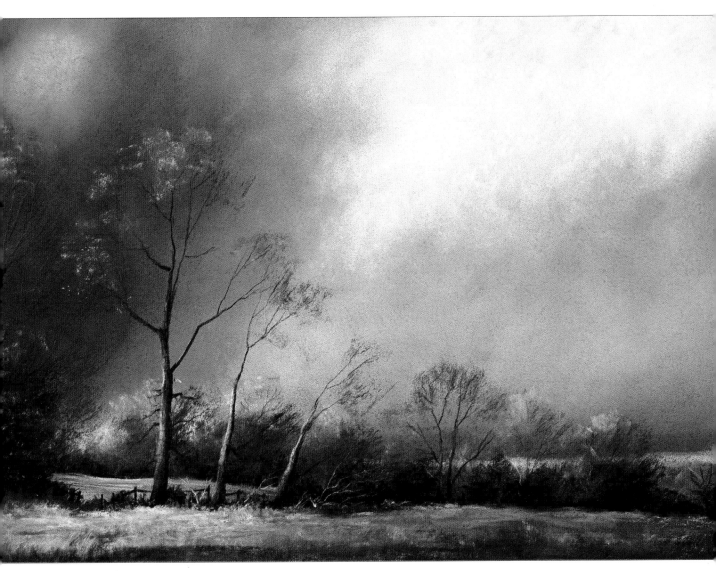

Between the Showers
Size: 510 x 380mm (20 x 15in)

When the sky is the dominant feature of a painting I tend to place my horizon line very low on the paper. Remember that other areas of the painting have to compete with the sky, and I have used a series of trees to link all the elements together. The emotional response to dramatic compositions such as this will be with the viewer. Has a storm just passed by to allow the sun to shine, or is this the sunny interlude before a cloudburst?

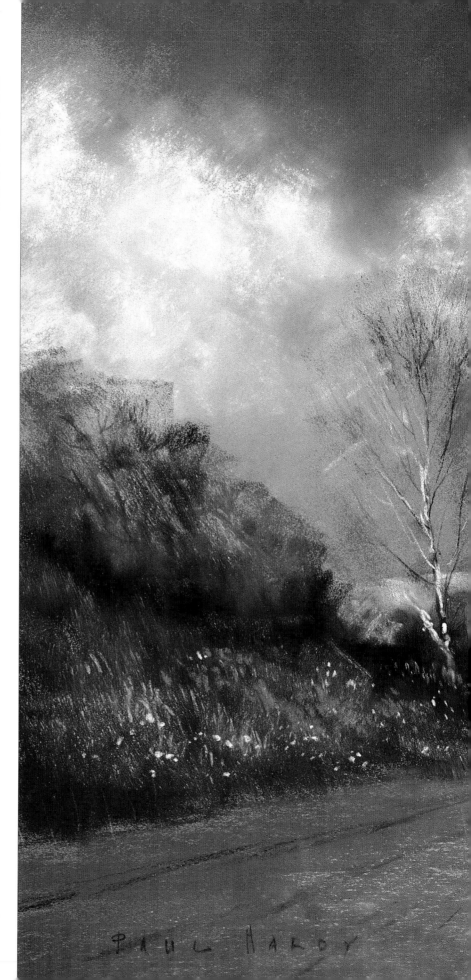

Bright Interval
380 x 305mm (15 x 12in)

The sky is the backdrop for every landscape and it can be used to create different moods. Here I have painted a dramatic, turbulent dark sky with clouds to contrast the stillness of the landscape. The sunlight in this painting has a luminosity and warmth that emphasises tonal values and colours.

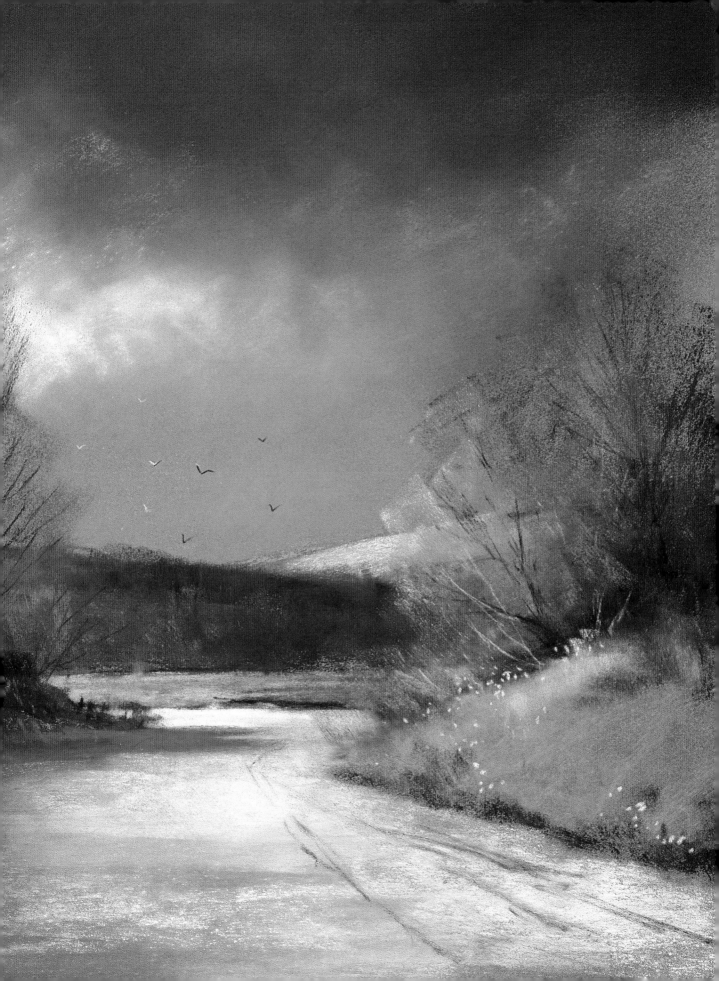

The Old Tree

The landscape contains a whole host of different types of trees, giving us a variety of shapes and forms to choose from. Most landscapes will depict trees *en masse* but, sometimes, a particular tree will inspire you to paint it. This can present quite a challenge to the beginner; the closer you are to the tree the more definition you must include in the painting. In this demonstration, I show you how I paint a tree portrait.

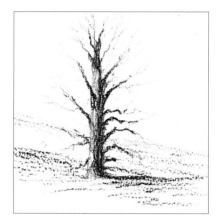

The tree in this demonstration is clothed with leaves, but it was based on this sketch of the bare branches and trunk of the oak. Remember to allow for the light source when drawing tonal sketches.

Colours

Black	Chrome yellow	Mauve
Blue/grey	Chrome green light	Olive green
Cadmium orange	Cobalt blue	Prussian blue
Cadmium yellow	Emerald green	Raw sienna
Cerulean blue	Hooker's green	Sap green
Charcoal pencil	Lemon yellow	Yellow ochre

1. Use a charcoal pencil to draw in the border, the horizon, the light source and the outlines for the distant hills.

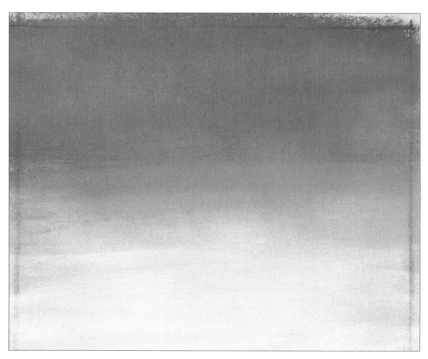

2. Block in the sky with cobalt blue, cerulean blue and a pale yellow ochre, and blend the colours together with the heel of your hand. Add touches of pale mauve to the top of the sky and blend.

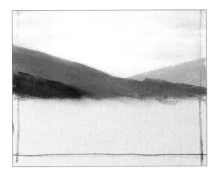

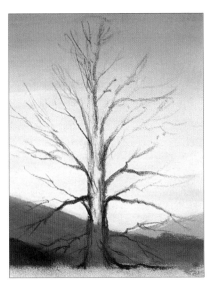

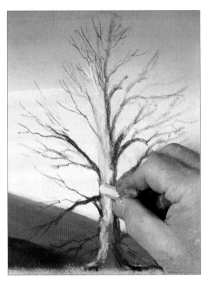

3. Use a pale blue/grey to block in the distant hillside, and mid and dark blue/grey for the near one. Use Prussian blue to suggest a distant group of trees. Overlay the near hillside and the trees with sap green, then use your finger to blend the colours together.

4. Now use a charcoal pencil to sketch in the skeleton of the tree.

5. Use cadmium yellow to add highlights to the tree trunk and the upper branches.

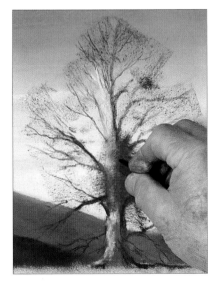

6. Use dark olive green to block in the shadowed parts of the foliage, skating across the surface to leave very pale marks.

7. Use dark olive green to add shadows to the right-hand side of the tree trunk and the major branches – away from the light source – and to the underside of the branches at the left-hand side.

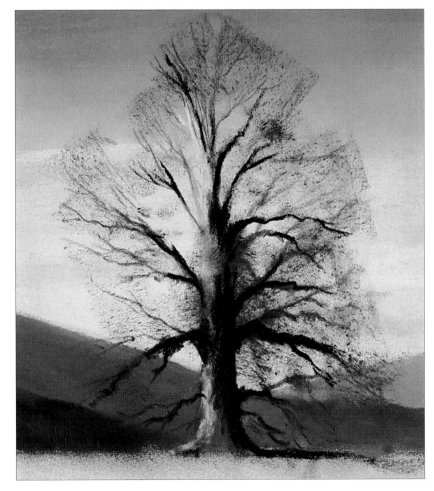

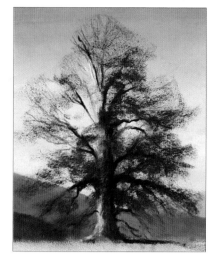

8. Use dark Hooker's green to start to develop the foliage.

9. Use mid sap green to work up shape and form, then use paler shades on the lit side of the tree. Use black to redefine the trunk and branches, and to emphasize the foliage at the back of the tree.

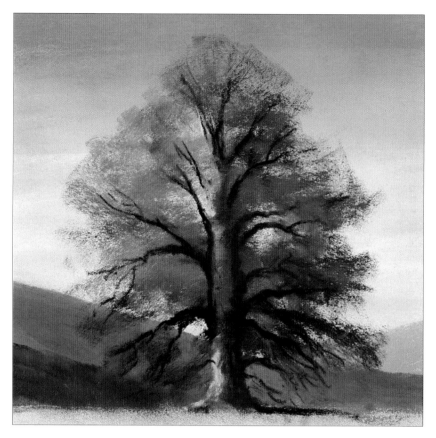

10. Now use a mid raw sienna to block in the foliage at the front of the tree.

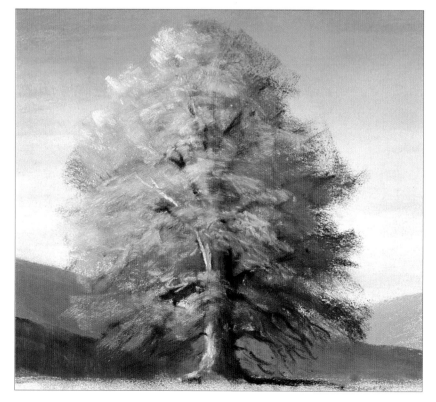

11. Continue developing the shapes with pale sap greens and chrome yellows. Reinstate parts of the trunk and branches with black and cadmium yellow. Add touches of mid emerald green and chrome green light to create highlights. Add texture by stippling tiny marks with greens and yellows.

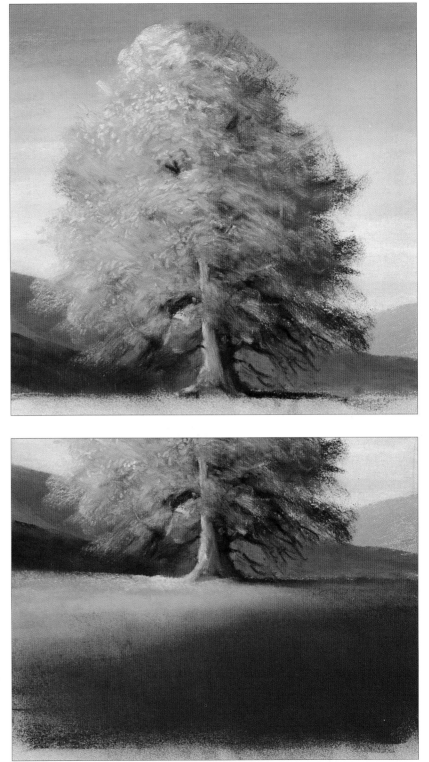

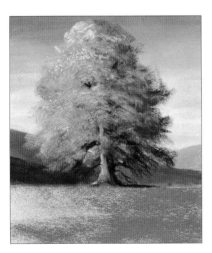

12. Block in the foreground using mid sap green overlaid with pale sap green. Remember that the lightest area is nearest to the light source.

13. Overlay the foreground with Prussian blue and lemon yellow. Blend the colours together. Reinstate the highlights on the tree trunk with cadmium yellow, and the shadows with Prussian blue.

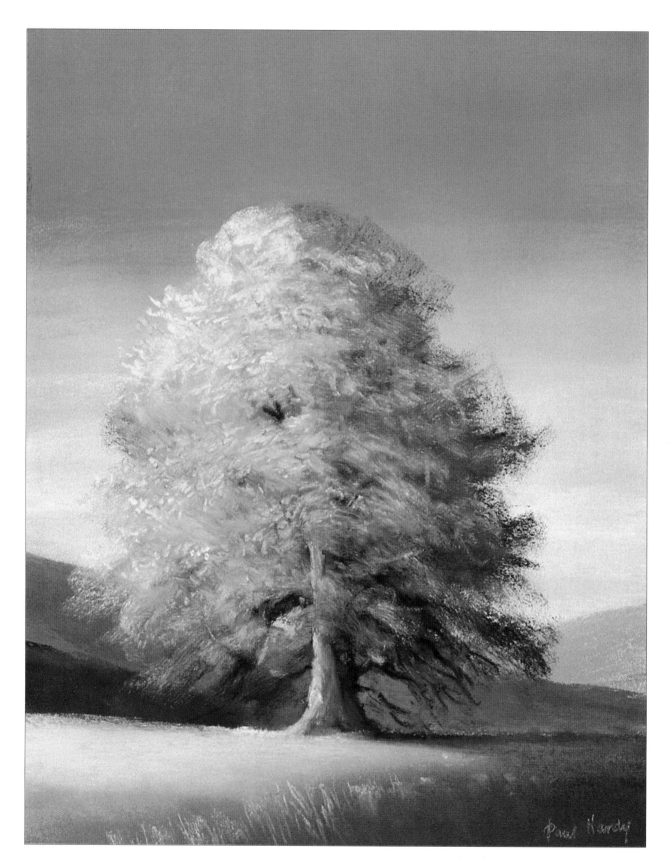

Paul Hardy

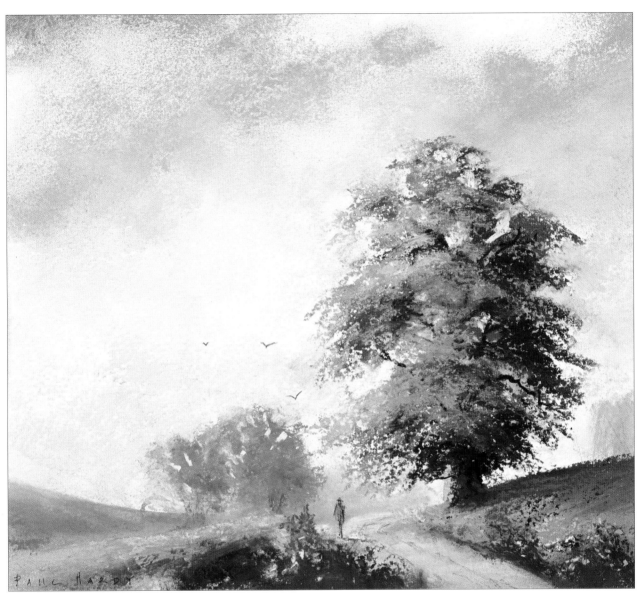

A Walk on the Moor
Size: 510 x 380mm (20 x 15in)

Paths and roads in a landscape help lead the eye into a painting. In this scene, the person walking along the road not only gives a sense of direction, but takes the eye into the scene more quickly. The use of linear perspective – notice how the road diminishes in the middle distance – and aerial perspective – the cool middle distance tree echoes the warmer tones of that in the foreground – combine to lead the viewer further into the picture towards the distant hills. This type of painting encourages the viewer to use their own emotions.

Opposite
The finished painting
235 x 295mm (9¼ x 11½in)

I added the suggestion of grass in the foreground by making a few marks with pale raw sienna and cadmium orange. Once again, I was not happy with the shape of the composition so I decided to crop it at the top and bottom.

35

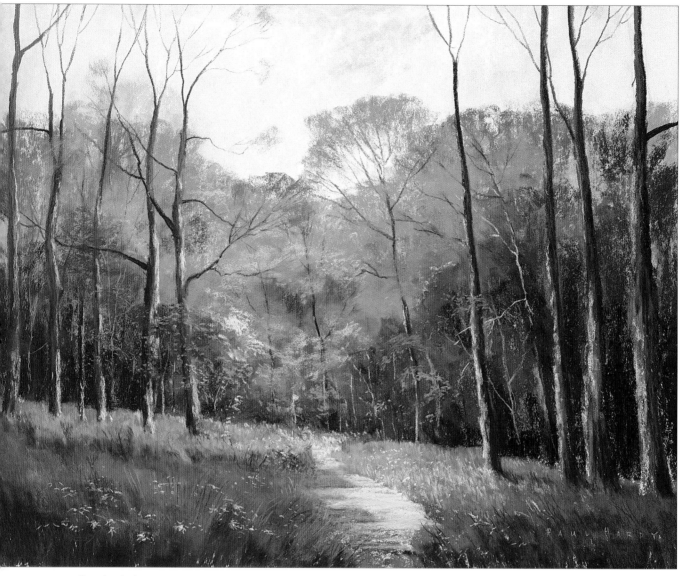

Woodland Glade
Size: 635 x 405mm (25 x 16in)

The sky has a small part to play in this painting, and is taken over by
a medley of colour which creates depth and contrast. It is not difficult
to imagine another world in this scene, nothing specific, but
complete in itself and quite seductive in it richness.

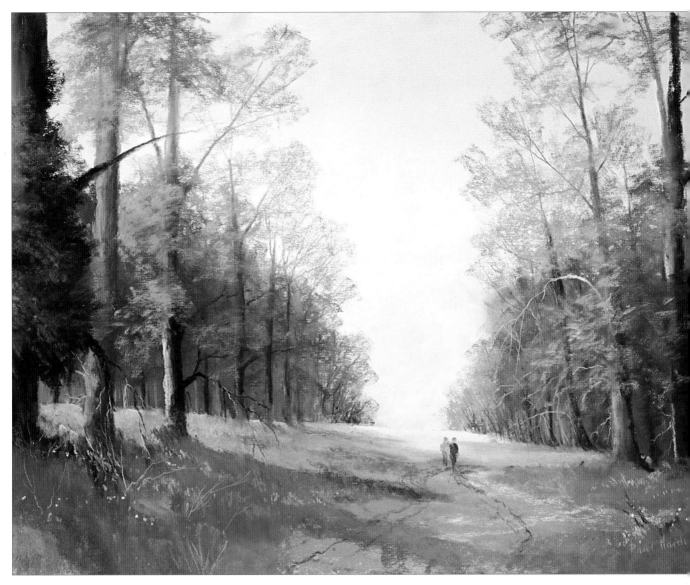

Two's Company

Size: 635 x 405mm (25 x 16in)

The season is obvious in this painting; it is a warm and sunny spring day, and the two people strolling through the bluebells are enjoying the flowers and each other's company. There is a sense of solitude but not loneliness, and their private world is open to public view for everyone to enjoy. This is an artist's inspiration and challenge.

A Sense of Peace

Water plays a prominent part in this painting and more or less dominates the composition. Water changes its mood very quickly, but, in this scene it is almost static, creating soft reflections on a mirror-like surface. The tones reflected in the foreground are quite dark, but they gradually get paler and paler towards the distant bank of the meadow. This is due to the fact that the distant surface of the water is at a more acute angle to the eye than that in the foreground and therefore reflects more light. The two trees balance the composition and hold it together by linking the river, its banks and the sky.

I painted this demonstration on a 560 x 380mm (22 x 15in) sheet of smooth pastel paper.

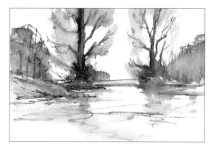

This tonal sketch, painted in sepia watercolour, was the inspiration for this demonstration.

Colours

Blue/grey	Hooker's green	Sepia pencil
Burnt sienna	Lemon yellow	Turquoise
Cadmium orange	Moss green	Ultramarine blue
Cadmium yellow	Prussian blue	Vandyke brown
Charcoal pencil	Raw umber	Yellow earth
Cobalt blue	Red earth	Yellow ochre
Grey	Sap green	White

1. Sketch in the outline of the scene. Block in the top left-hand area of the sky with mid grey, then overlay the extreme top left-hand corner with dark cobalt blue. Repeat these colours in the water. Lay in turquoise over centre area of sky and water, then add some cobalt blue and ultramarine blue. Block in the lower part of the sky with pale yellow ochre, taking it up into the blues, then apply touches of very pale yellow ochre. Again, repeat these colours in the water. Finally add white highlights on the distant stretch of water.

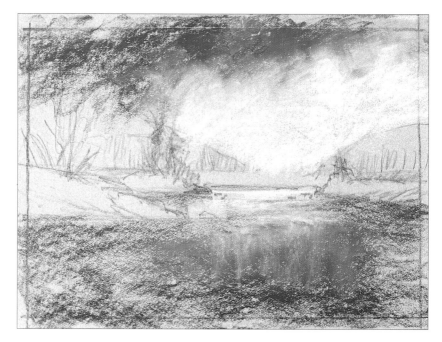

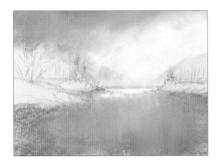

2. Blend all the colours together.

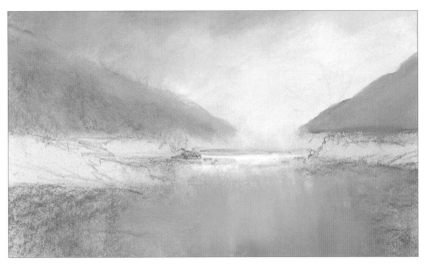

3. Use tones of sap green and Hooker's green to block the middle-distant hills. Use the same colours to indicate reflections in the water.

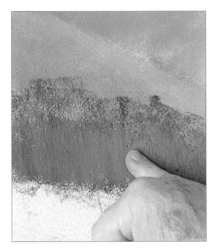

4. Use a mid blue/grey to block in the distant trees, then use deep Prussian blue to add shape and form. Finger blend just the bottom (dense) area of these trees.

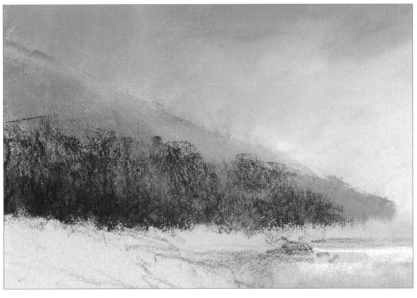

5. Continue building up the shapes of the trees with very dark Hooker's green, then use touches of dark burnt sienna to create the feel of autumn.

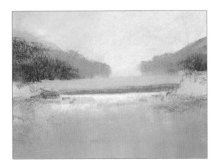

6. Use pale sap greens to block in the distant meadow, using the tip of the pastel to make strong marks, then overlay these marks with mid yellow ochre. Use raw umber to block in the distant river bank. Blend these colours into the distant trees.

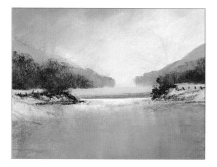

7. Use deep turquoise to block in the bushes on the river banks, to define the edges of the water and to draw in details such as the fence posts (at right and left).

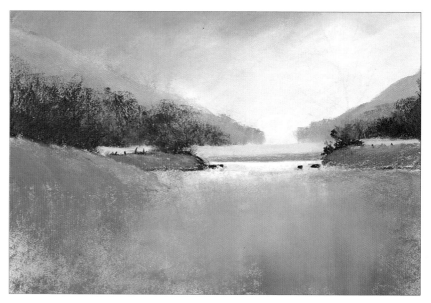

8. Use the deep turquoise to add a few rocks adjacent to the right-hand river bank. Use yellow earth to block in the near banks of the river and their reflections, then overlay these marks with mid yellow ochre to create shape. Blend the colours together. Use dark moss green to add tone to the river banks and reflections.

9. Use a charcoal pencil to darken the bushes, to redefine the edge of the water and to create shadows on the river banks. Use a finger to drag vertical reflections down into the water.

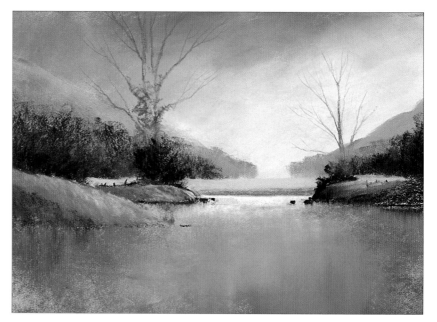

10. Add cadmium yellow highlights on the grasses. Use a sepia pastel pencil to define the skeletons of the trees on either side of the river.

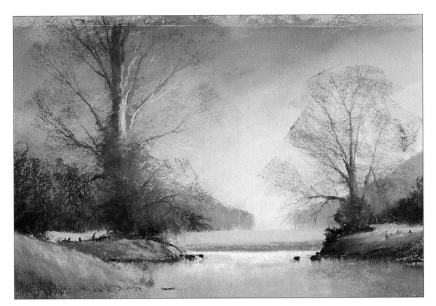

11. Use a charcoal pencil to develop the shadowed parts of both trees and accentuate their branches. Note the ivy growing on the lower part of the left-hand tree. Use a charcoal pencil to define the smaller branches – the branches against the pale sky are obviously more pronounced.

12. Break up some of the dark areas of the trunks with mid sap green. Use a very pale yellow ochre to create highlights on the trunks. Use the sides of mid Vandyke brown and yellow earth pastels to suggest areas of foliage. Redefine highlights on the trunks with a pale cadmium yellow.

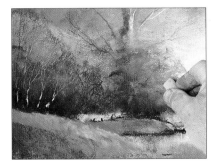

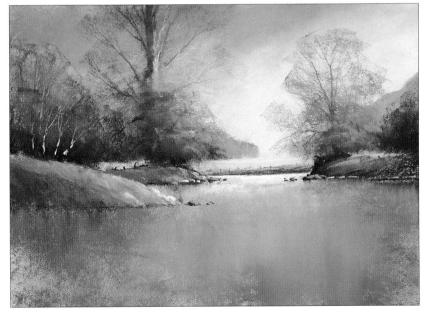

13. Use white to suggest thin tree trunks at the left-hand side. Start to develop the foliage on the trees using mid red earth, mid yellow ochre, cadmium orange and cadmium yellow. Use the same colours to suggest fallen leaves on the river bank.

14. Use a charcoal pencil to redefine the far river bank, to add an indication of fence posts on the distant meadow and to add more rocks. Use cadmium yellow to create highlights.

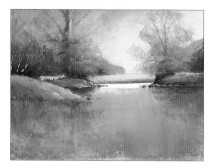

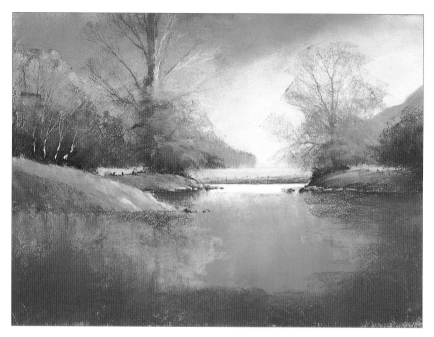

15. Use dark Prussian blue to add reflections close to the middle distant river bank, then, using the autumnal colours used to clothe the trees, block in their reflections.

16. Darken the foreground area with very dark Hooker's green, then overlay this with lighter tones of the same colour.

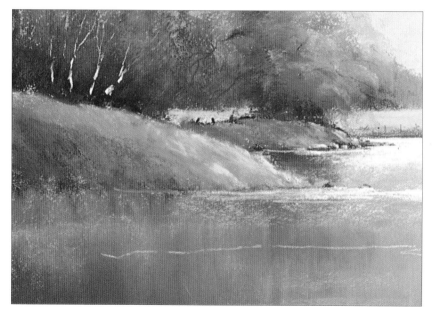

17. Use the heel of your hand to drag reflections of these colours down into the foreground water.

18. Use the side and tip of a white pastel to lay in highlights on the surface of the water.

19. Use the side of the pastel, add fine broad strokes of very pale lemon yellow on the water, then blend them vertically into the under colours. Finally use the tip of a very pale sap green pastel to add a few ripples.

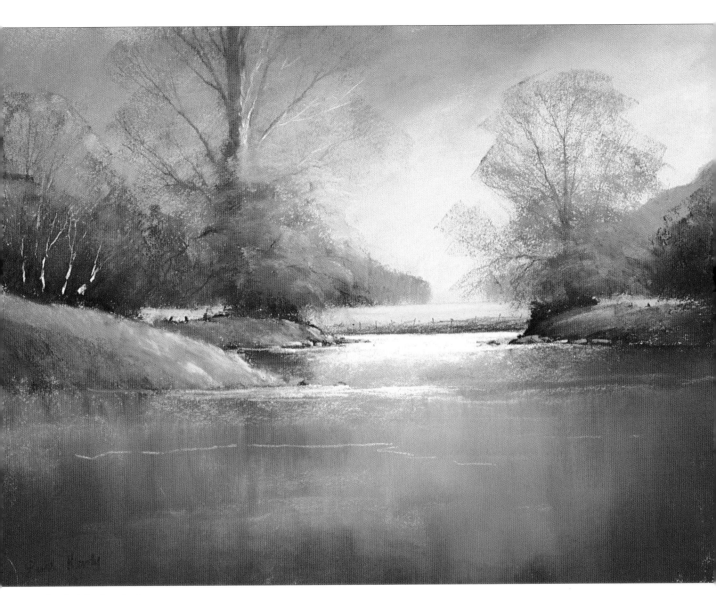

The finished painting
Size: 485 x 355mm (19 x 14in)

43

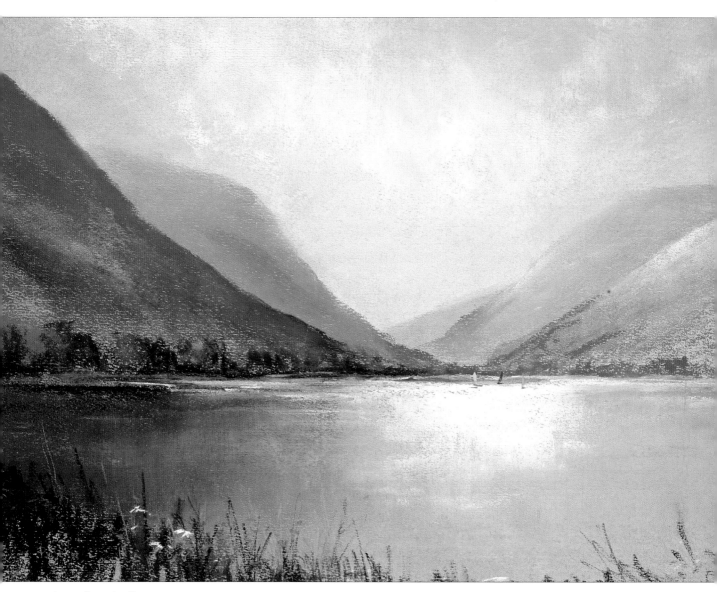

Away from it all
Size: 635 x 405mm (25 x 16in)

There is a sense of grandeur here on a large scale. The vista is panoramic, but, at the same time, it is within the view of the beholder. Comprehensive views that take in distance make spectacular compositions. We may be looking for a focal point, which I have defined by the almost incidental introduction of sailing boats on the water. Here, we have a balanced distribution of light and colour. There is no tension in this painting.

Opposite
The Old Bridge
Size: 380 x 510mm (15 x 20in)

Sometimes we see a scene where scintillating colour is dominant. This can be unsettling, but, in this case, it is unified into a whole. This is not a large painting and can be contained. The bridge is the centre of interest, and everything else leads the eye to it.

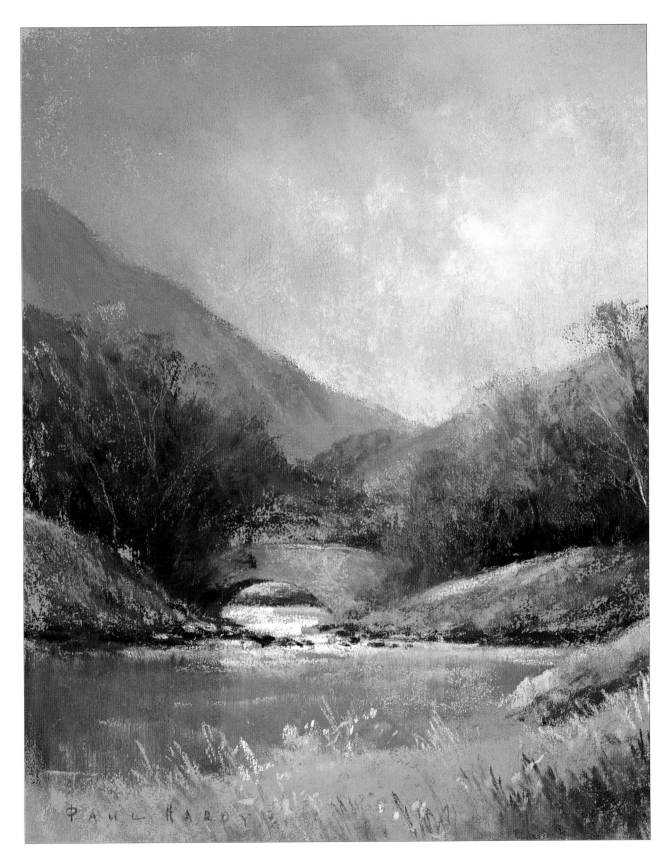

More Snow!

Size: 635 x 405mm (25 x 16in)

In winter, the landscape is reduced to basics. Snow does simplify everything and softness prevails. Contrast is an immediate result, introducing shadow patterns, dipping and rising or stretching evenly over meadows. The introduction of colour is due to sunlight, out of the picture, picking up the remaining leaves on the trees.

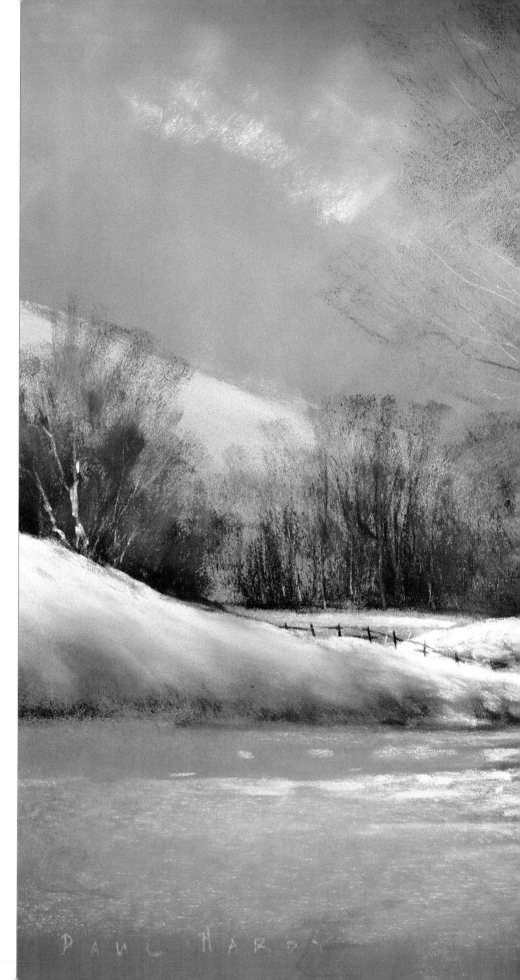

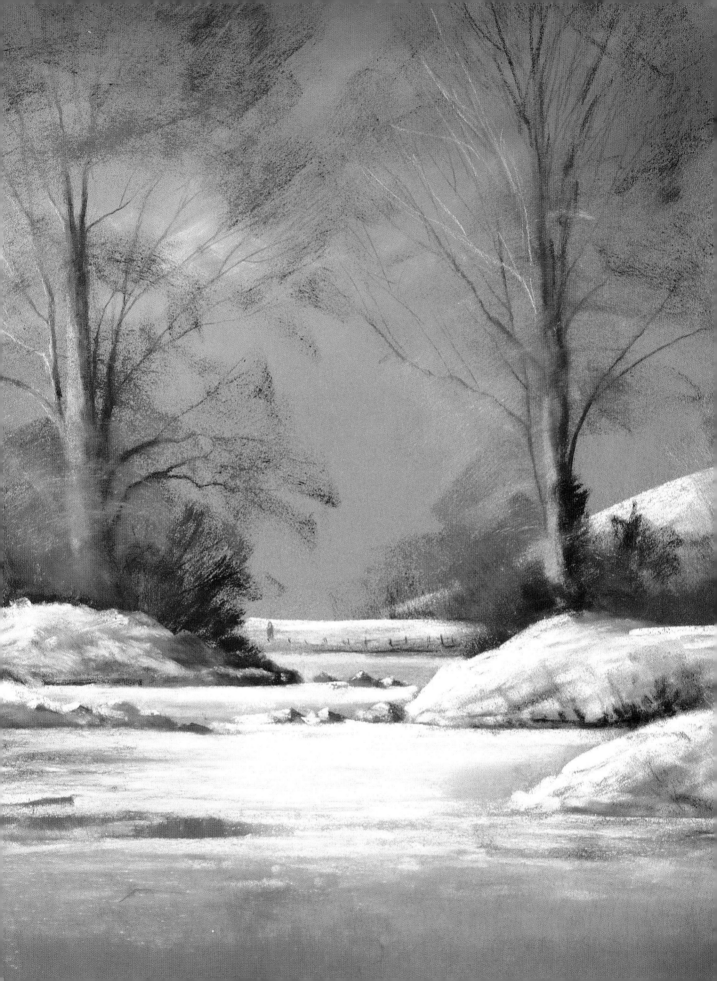

Index

__Light and Shade__
Size: 380 x 205mm (15 x 8in)

In this painting, the simplicity of the small group of trees encapsulates the atmosphere of autumn. There is a fusing of colour here which gives balance. This and every painting should not need an explanation; the viewer has to connect with the subject.

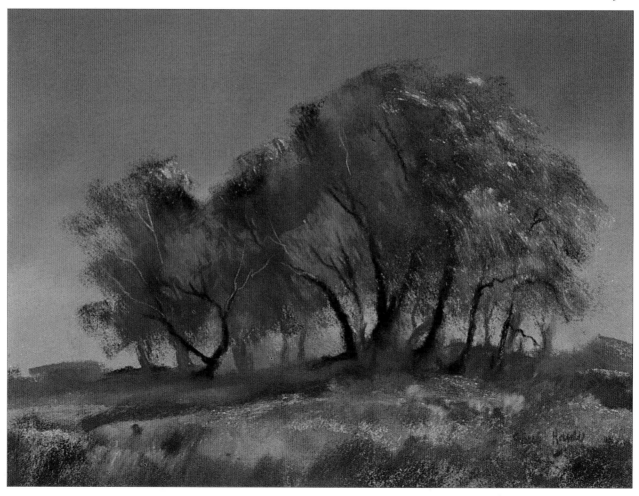